SHOW-ME-HOW
I Can Paint

Painting activity projects
for the very young

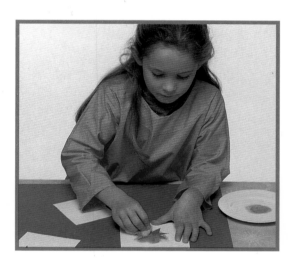
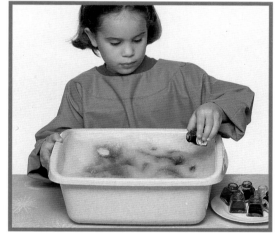
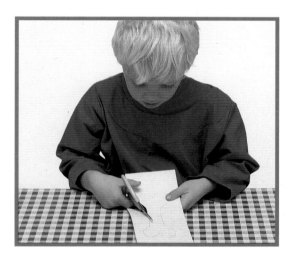
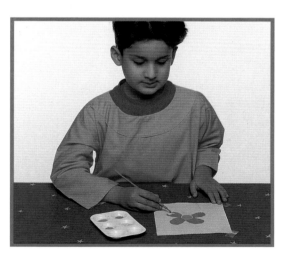

PETRA BOASE

INDEX

First published in 1995 by Lorenz Books
an imprint of Anness Publishing Limited
1 Boundary Row
London SE1 8HP

This edition published in Australia in 1995
by Koala Book Company, 722 Bourke Street,
Redfern, N.S.W. 2016, Australia

ISBN 1 85967 068 7

A CIP catalogue record of this book
is available from the British Library.

Publisher: Joanna Lorenz
Project Editor: Clare Nicholson
Designer: Edward Kinsey
Photographer: John Freeman

Printed and bound in Hong Kong

PLEASE NOTE
**The level of adult supervision will depend on
the ability and age of the children following
the projects. However, we advise that adult
supervision is always preferable, and vital if the
project calls for the use of sharp knives or other
utensils. Always keep potentially dangerous
tools and products well out of the reach of
young children.**

ACKNOWLEDGEMENTS
The publishers would like to thank the following
children for appearing in this book, and of course
their parents: Tania and Joshua Ayshford,
Venetia Barrett, Jessica Moxley, Kirsty Fraser,
Alice Granville, Sasha Howarth, Nicholas Lie
and Aaron Singh.

Contents

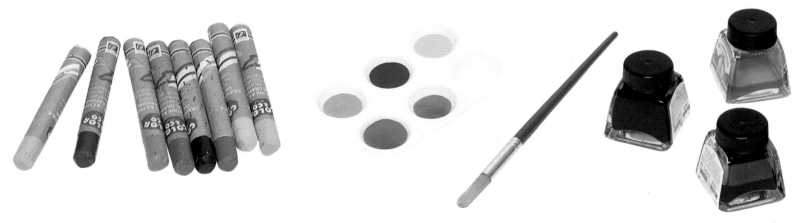

Introduction

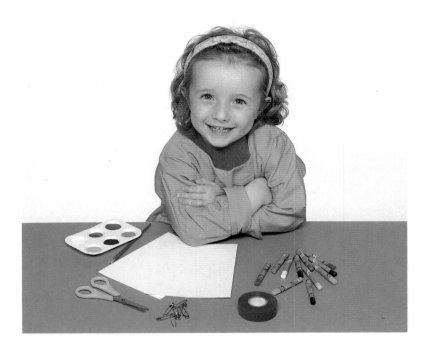

Painting is fun, but painting does not necessarily mean standing at an easel painting a picture of what you can see – although you can do that too if you want. The projects in this book show you how to have lots of fun with different sorts of paints on lots of different surfaces.

None of the projects in this book is difficult, although there are a few things you should do before you begin.

1. Carefully read through the list of materials you will need.

2. Read through the instructions and look at the photographs so that you have a clear idea of what you will be doing.

3. Assemble everything you need before you start on a project.

4. Some of the projects are messy and some aren't, but it is always a good idea to cover your work surface with newspaper, scrap paper or a piece of material. If you are working on a wipe-clean surface and doing one of the less messy projects, this is not essential, but it is a good idea to get into the habit.

5. Wear an old shirt or a painting overall and, when you have finished, always clear away everything you have used.

You may not want a grown-up around while you are being creative, but there are some things that you will need help with. Some of the projects call for sharp scissors and you may prefer a grown-up to do the cutting for you. Some types of card are easier to cut with a craft knife. These knives are very sharp and are quite tricky to use, so always get a grown-up to do any cutting with a craft knife. Always ask a grown-up to mix and thin oil paints for you as well. You can mix other kinds of paint such as water colour and poster paint yourself.

Wear an old shirt or painting overall.

Before you begin, make sure you have everything you will need.

Colour mixing

You don't need a lot of different coloured paints to do the projects in this book. It is easy to mix lots of colours as long as you have the three primary colours of red, blue and yellow.

Red + Blue = Purple
Red + Yellow = Orange
Blue + Yellow = Green

You can make different sorts of browns by mixing purple and orange, orange and green and purple and green.

If you start off with red, yellow and blue and, perhaps, white (with which you can make pink and pale shades of the other colours), you can easily add more colours as your pocket money allows. You will also need black paint for some of the projects so check before you begin.

Be careful when you use scissors.

Templates

Some of the projects in this book have pattern templates for you to trace. You will find these on the following pages.

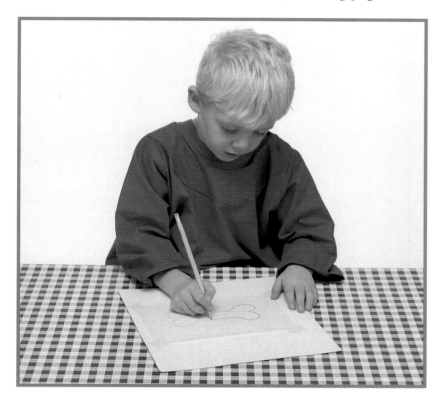

1 Place a sheet of tracing paper over the template pattern in the book. Hold the paper in position with your spare hand. Carefully trace the pattern using a soft pencil.

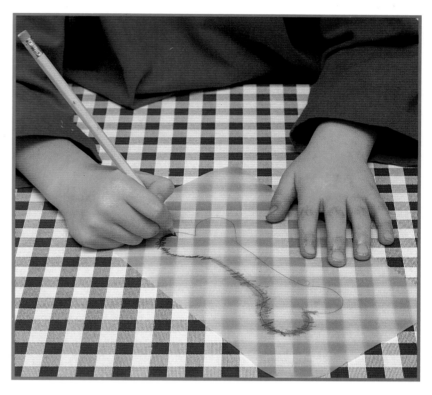

2 To transfer your pattern on to cardboard or paper, turn the tracing paper over and scribble over the outline with your pencil.

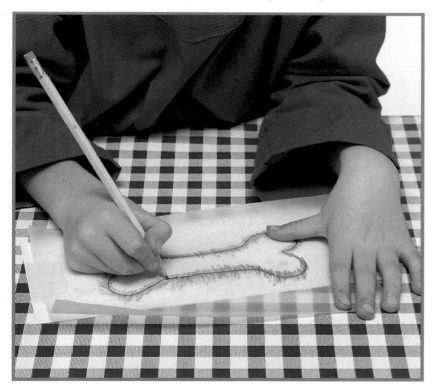

3 Turn the sheet of tracing paper over again and place it on your sheet of cardboard. Draw around the outline of the pattern firmly. It will transfer on to the paper or cardboard.

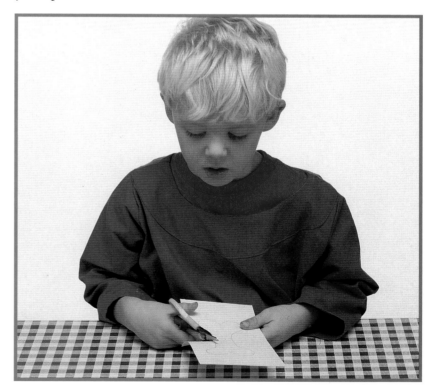

4 Remove the tracing paper and make sure all the pattern has been transferred. Use the scissors to cut out the template, and then draw around it as shown in the project pictures.

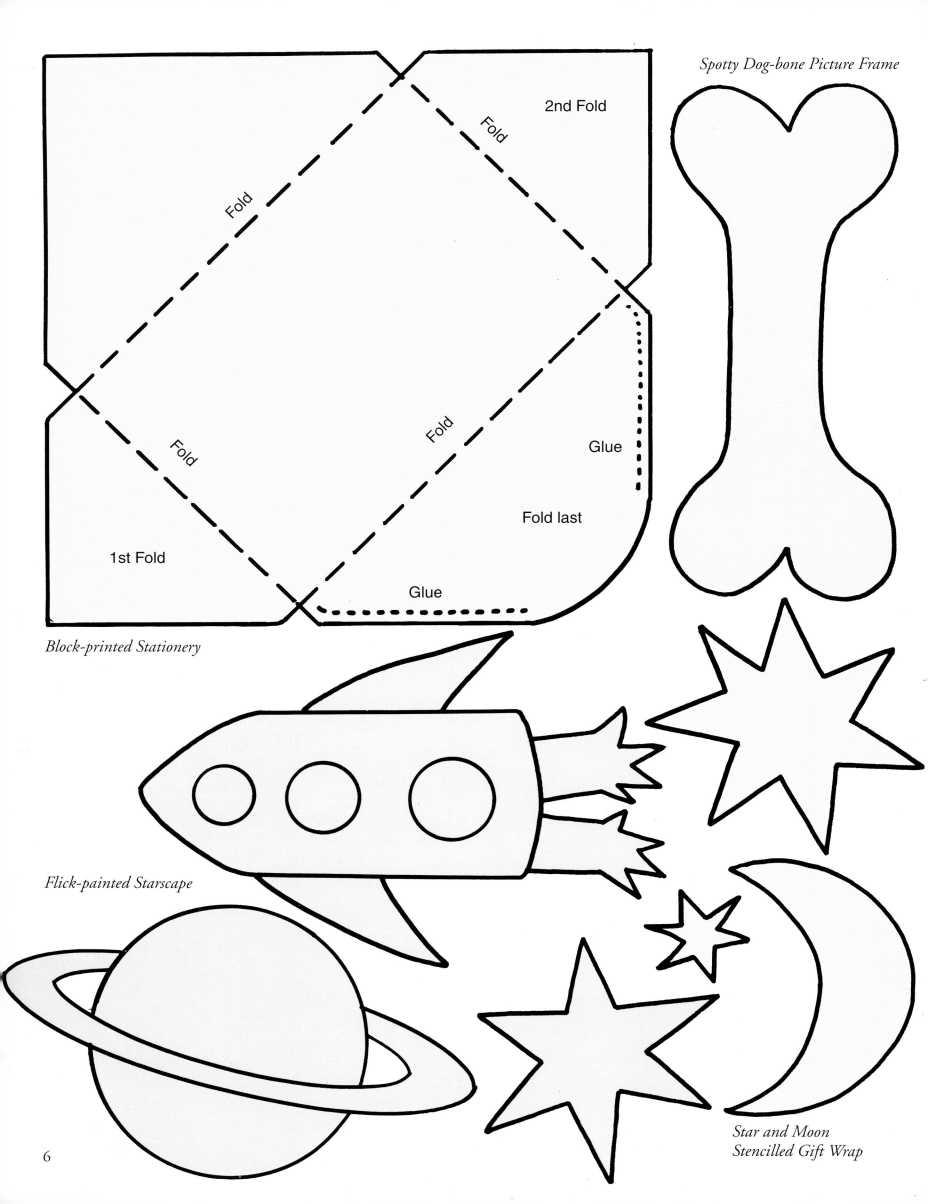

2nd Fold

Fold

Fold

1st Fold

Fold

Fold

Glue

Fold last

Glue

Block-printed Stationery

Spotty Dog-bone Picture Frame

Flick-painted Starscape

*Star and Moon
Stencilled Gift Wrap*

6

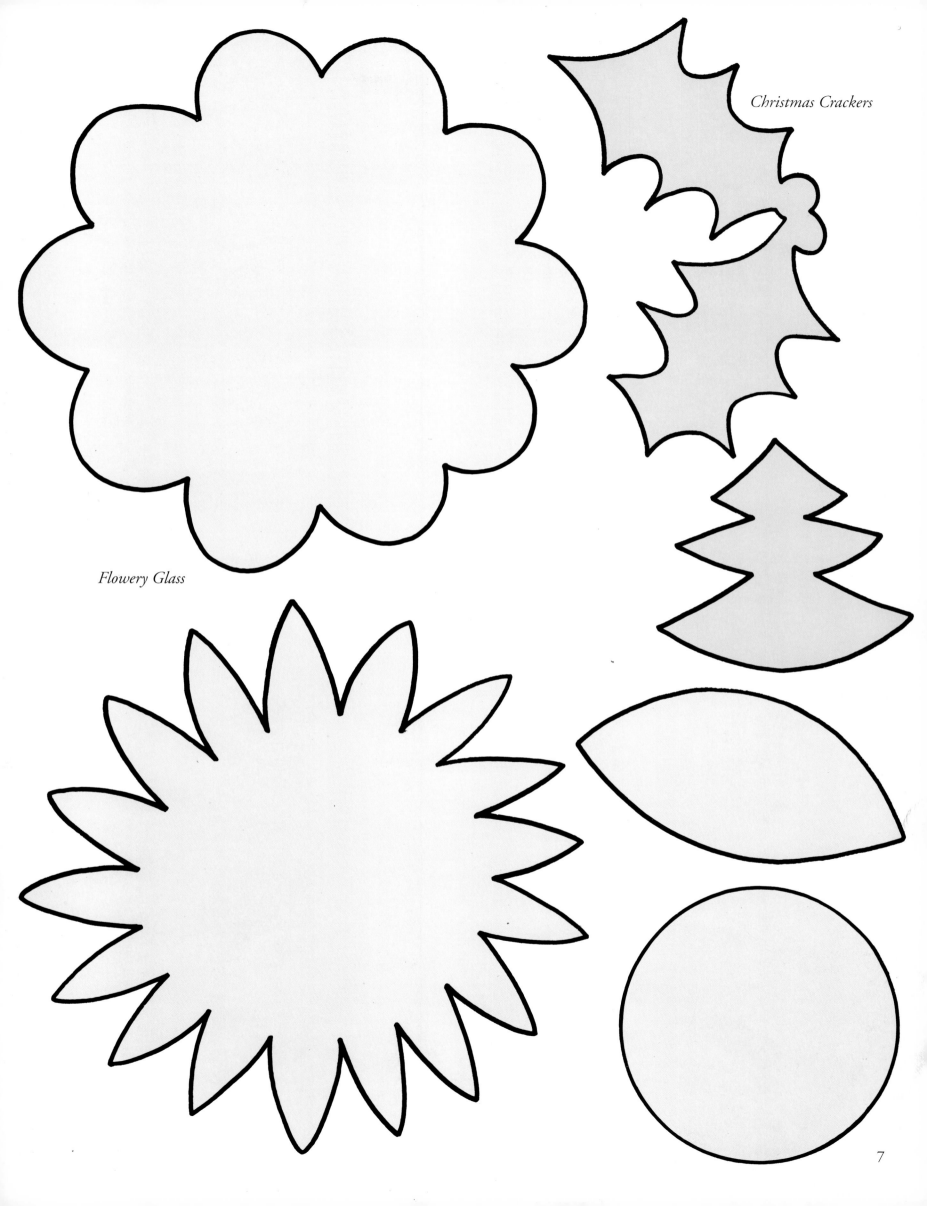

Christmas Crackers

Flowery Glass

Equipment

These are the general pieces of equipment that you will need throughout the book. Other items are listed individually by project.

Paint palette If you don't have a paint palette you can use an old plate or saucer. Remember to wash whatever you use thoroughly at the end of a project and don't use a plate to eat from once it has been used for paint.

Plastic cups These make ideal containers for mixing paints in, but you can't drink from them afterwards. Alternatives are clean jam or coffee jars.

Sticky tape This is available in a variety of widths and colours and is useful for sticking small things together.

Painting beakers Painting beakers with lids allow you to store runny paint from session to session.

Cloth It is always a good idea to have a cloth with you when you are working on a project, just in case you have an accident and you need to clean it up quickly.

Pencils Soft pencils are best for tracing out templates and for drawing out designs before painting.

Rubber If you make a mistake when drawing with a pencil simply rub it out.

Pencil sharpener Use this to keep your pencil sharp which makes it easier to draw clean lines.

Paintbrushes These are available in many different shapes and sizes. If you are painting large areas, use bigger brushes and, if you are painting fine lines, use thinner brushes. In order to make them last, you must look after them, washing them out in cold water after using them with water-based paints or in turpentine or white spirit if you have used them with oil-based paints.

Ruler A ruler is useful for measuring and for drawing straight lines.

Scissors Scissors are used for cutting out paper. Always have a grown-up close by when you are using scissors.

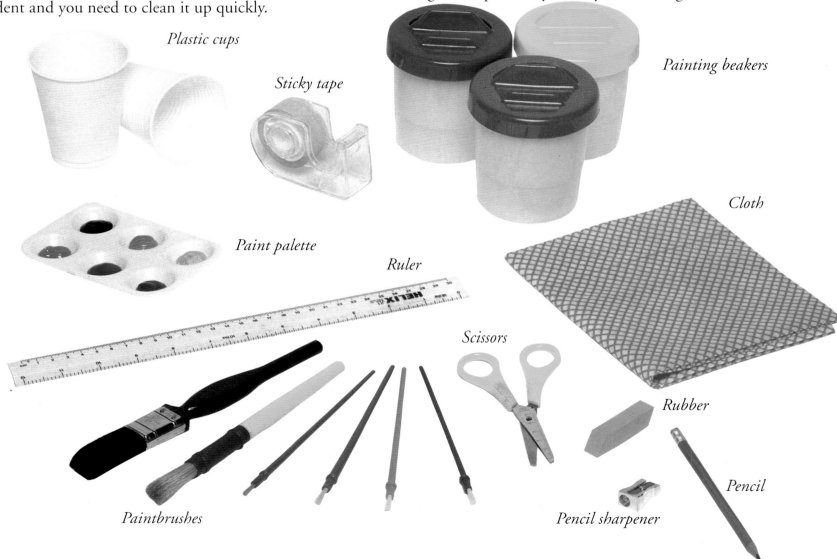

Plastic cups

Sticky tape

Painting beakers

Cloth

Paint palette

Ruler

Scissors

Rubber

Pencil

Paintbrushes

Pencil sharpener

Materials

Each type of paint is different and takes different times to dry. Always read the instructions on the pot or tube before you start.

Acrylic paint This is rubber-based and non-shiny so that it covers large areas easily but does not have the shine of oil paint or the texture of water-based paint.

Poster paint This is water-based and is available either as a powder to be mixed with water, or ready-mixed.

Fabric paint Fabric paint is necessary for painting or printing on textiles. Each type is different so read the instructions carefully and clean your brushes accordingly.

Coloured inks These are available in a wide variety of colours. If you can't find any, or can't get a colour you want, you can use food colourings instead. Always make sure they are washable.

Oil paints These are very greasy and must be handled with care. Ask a grown-up to mix white spirit or turpentine with oil colours to thin them. Ask an adult to clean your brushes with white spirit or turpentine.

Wax crayons These are used in wax-resist paintings. If you don't have any crayons you can use candles instead.

PVA glue PVA glue is an all-purpose adhesive for paper and card. Keep it away from your mouth and follow the instructions on the container. Use a brush or a glue spreader to put it on.

Card Card comes in many different thicknesses. If you are making a template from card, you will need thin card. For this you can use a cereal packet. If you need thick card try using a cardboard box.

Tracing paper Tracing paper is a clear paper necessary for the projects that involve tracing over templates. Use greaseproof paper as an alternative.

Paper Paper is available in a variety of colours and weights. Cartridge paper is good for painting and drawing on, but for some of the projects lining paper (from DIY shops) will give good results and is much cheaper. Some of the projects call for coloured paper which you can get from stationers and craft shops.

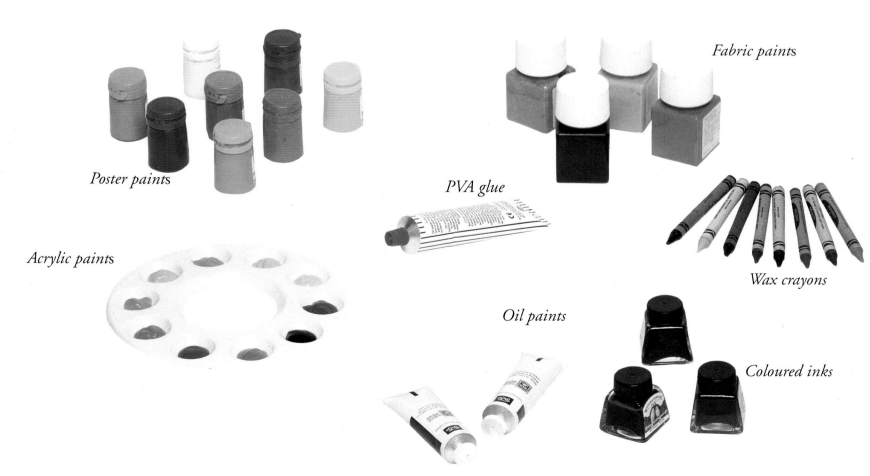

Poster paints

Acrylic paints

PVA glue

Fabric paints

Wax crayons

Oil paints

Coloured inks

Star and Moon Stencilled Gift Wrap

If you have always wanted to make your own special gift wrap and matching greetings cards, now is your chance.

The moon and star shapes that Kirsty is stencilling are simple. She is only using gold paint, but you can use lots of different colours. If you want to stencil with lots of colours, use a different sponge for each colour and let each colour dry thoroughly before you add the next.

Stencilling technique

Stencilling is great fun and easy to do. For the best results, the paint needs to be thick, so don't mix any water with it. Do not use too much paint on the sponge, and apply it with a light dabbing movement. You can always go over it again to add more colour.

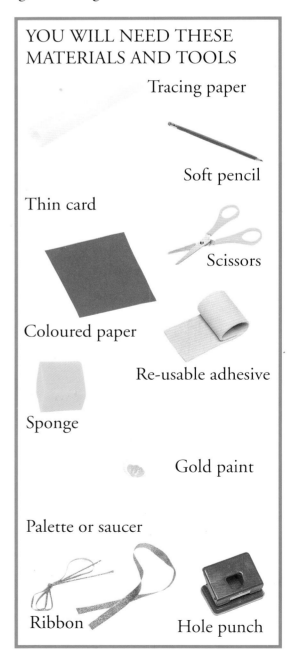

YOU WILL NEED THESE MATERIALS AND TOOLS

Tracing paper

Soft pencil

Thin card

Scissors

Coloured paper

Re-usable adhesive

Sponge

Gold paint

Palette or saucer

Ribbon

Hole punch

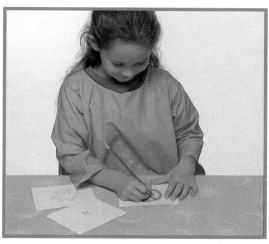

1 Using a soft pencil, trace the star and moon templates on page 6 on to card, as shown on page 5.

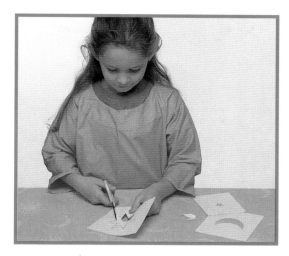

2 Use the scissors to make a hole in the middle of the design, and then cut towards the shape. You should have three different stencils.

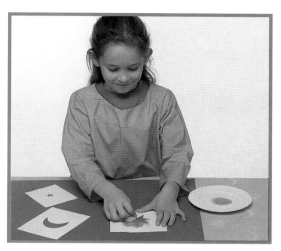

3 Place the stencils on the coloured paper. Secure them with re-usable adhesive. Dab the sponge in the gold paint and sponge over the stencils.

4 Let the paint dry, then move the stencils to another space on the paper and repeat. Continue until you have covered the whole sheet with gold moons and stars.

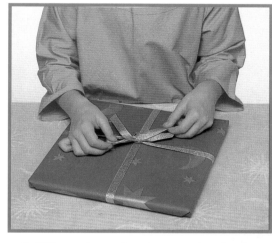

5 When the paint is completely dry, use the sheet of paper to wrap up a present. To make the gift extremely luxurious, add a gold ribbon and tie a bow.

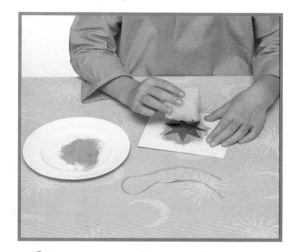

6 Cut out a small piece of paper and stencil it in the same way to make a gift tag for the present. Using a hole punch, make a hole in the corner and slip a piece of gold ribbon through.

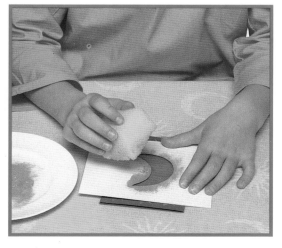

7 Here a moon is being stencilled on to a card for a different design.

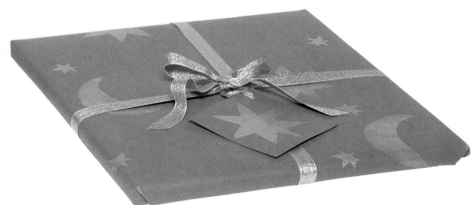

A unique set of gift wrap for a very special present.

Christmas Crackers

Your family and friends will be delighted when you present them with these pretty crackers at the Christmas meal or at a party. You must plan this project in advance as you need a cardboard tube for each cracker.

Jessica is using traditional Christmas shapes and colours in her design, but you could choose your own instead.

Presents galore

If you are feeling generous you could also put a little gift inside each cracker, and perhaps write a joke to go inside as well. This should be done in step 7, when you have closed only one end of the cracker.

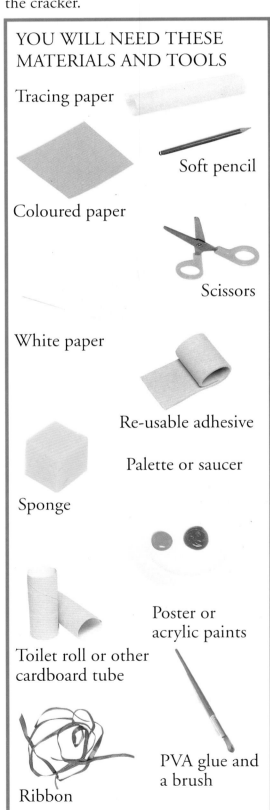

YOU WILL NEED THESE MATERIALS AND TOOLS

Tracing paper

Soft pencil

Coloured paper

Scissors

White paper

Re-usable adhesive

Palette or saucer

Sponge

Poster or acrylic paints

Toilet roll or other cardboard tube

PVA glue and a brush

Ribbon

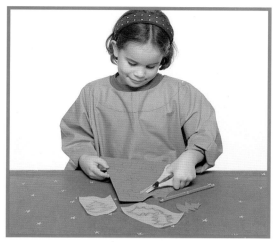

1 Trace the holly leaf and Christmas tree templates on page 7 on to coloured paper, as shown on page 5. Cut them out.

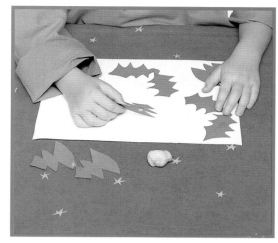

2 Scatter the shapes over the white paper, sticking them down with a piece of re-usable adhesive. Your pattern can be regular or random.

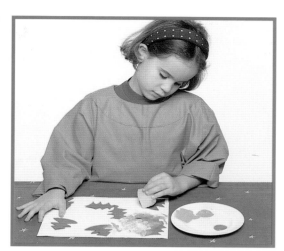

3 Dab the sponge into one of the paints. Wipe off any excess on the side of the palette. Sponge over all the shapes on the paper.

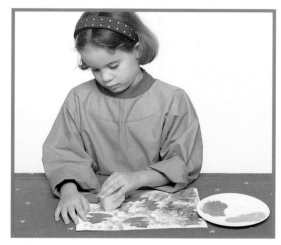

4 Rinse the sponge out under the tap, squeezing it as dry as you can. Dab it in the second paint colour and sponge over the shapes again.

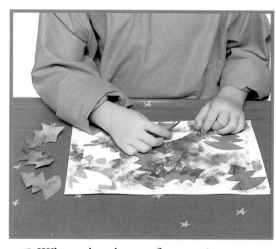

5 When the sheet of paper is completely dry, gently peel the templates away to reveal a colourful Christmas design. Place it face down on your work surface.

6 Brush glue all over the cardboard tube. Place it halfway along one edge of the sheet of paper. Carefully roll the paper around the tube. Glue the edge down.

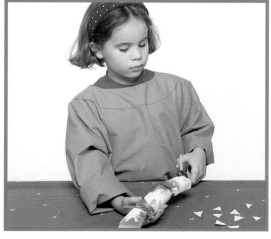

7 Feel where the ends of the tube are and pinch in the paper there. Finally, cut triangles from the ends of the paper and add ribbons.

The ideal table decoration for a Christmas party.

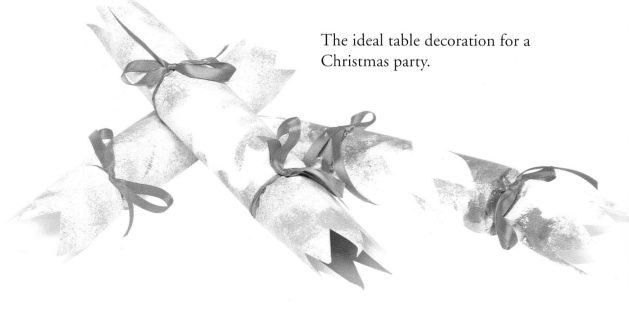

Painted Stones Caterpillar

If you are unable to get to the seaside to collect the pebbles, make some from self-hardening clay which can be bought in craft and hobby shops. When you have painted the pebbles with pictures or numbers, you will have hours of fun with them. Joshua is being clever with his pebbles by painting a caterpillar on one side and numbers and mathematical signs on the other, so that he can practise his sums and see how brainy he is.

Painting tips

You will find it easier to paint half of all the stones, then go back and finish them off. In this way, you won't be trying to hold an area of stone that is already wet.

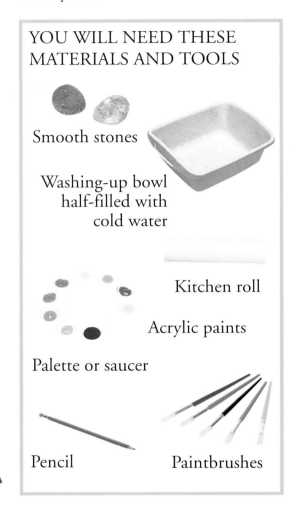

YOU WILL NEED THESE MATERIALS AND TOOLS

Smooth stones

Washing-up bowl half-filled with cold water

Kitchen roll

Acrylic paints

Palette or saucer

Pencil

Paintbrushes

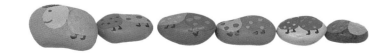

14

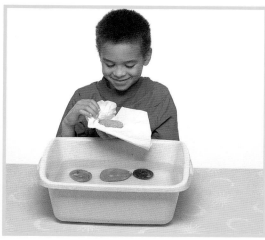

1 Wash the stones in the washing-up bowl and dry them well with kitchen roll. Use as many as you like.

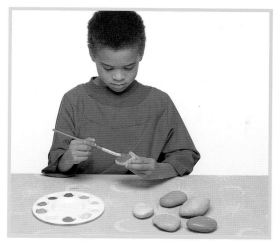

2 Paint the stones. Try to make each one a different colour. Leave them on your work surface until they are completely dry.

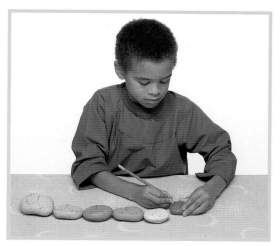

3 Arrange the stones in a long line with the biggest at one end and the smallest at the other. Draw a caterpillar design on them.

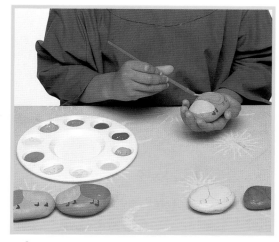

4 Paint the caterpillar's body using different colours. Use black, brown or another dark colour for its feet.

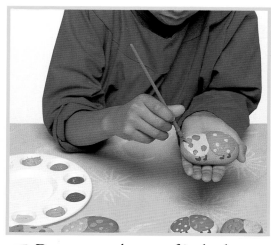

5 Decorate each part of its body with different coloured spots. You can vary the size of the spots too.

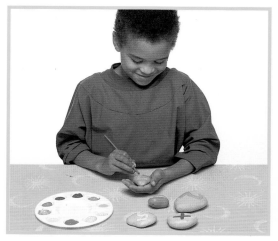

6 Either use a new set of painted stones, or wait until the caterpillar is dry and turn the stones over. Paint in some figures and mathematical symbols.

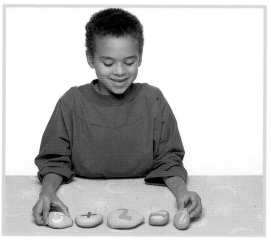

7 Impress your family and friends by showing them how clever you are.

None of your papers will blow away when the caterpillar is weighing them down.

Butterfly Blottography Box

Blottography prints are easy to do and the results are always an exciting surprise. This technique is at least 100 years old. Alice is using her prints to brighten up a storage box, but you could also stick a blottography shape to a tray and varnish over it – ask a grown-up to help with this.

Blottography technique
Be sure to use a large piece of paper for your prints so that paint doesn't ooze out over everything and make a mess.

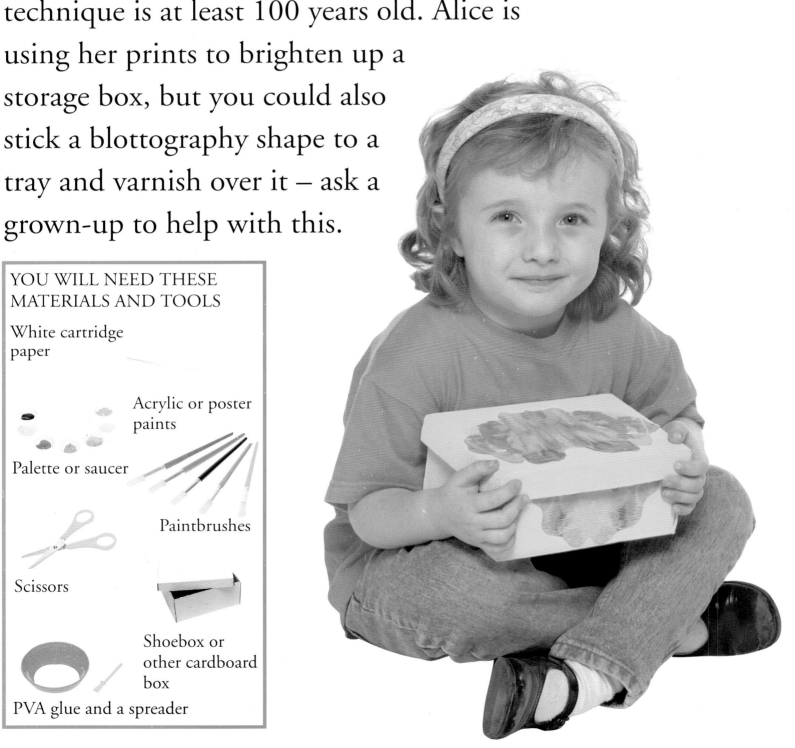

YOU WILL NEED THESE MATERIALS AND TOOLS

White cartridge paper

Acrylic or poster paints

Palette or saucer

Paintbrushes

Scissors

Shoebox or other cardboard box

PVA glue and a spreader

16

1 Make sure that your sheet of paper is longer than it is wide. Fold it in half lengthways.

2 Open up the paper and dab generous spots of paint on one side only. Use as many different colours as you like, but don't get it *too* runny.

3 Fold the paper in half once again, bringing the dry side over on to the wet side. Carefully smooth it down with your hand.

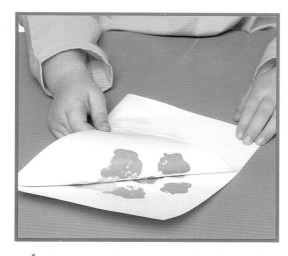

4 Open up the paper and admire the colourful, symmetrical pattern you have created on both sides of the paper. Leave it to dry thoroughly.

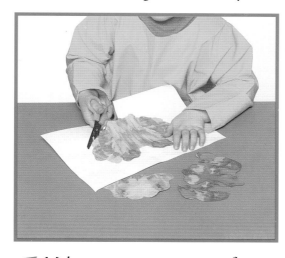

5 Make some more patterns of different sizes and using different colour combinations in the same way. Try using all pale colours or all dark. Cut them out when they are dry.

A colourful way of storing your odds and ends.

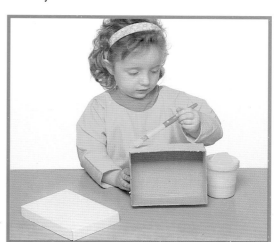

6 Paint the cardboard box inside and out. If you are using a shoe-box, or any other box that was coloured to start with, you will find it easier to cover the existing colour if you use acrylic paint. Poster paint is fine if your box is white to start with.

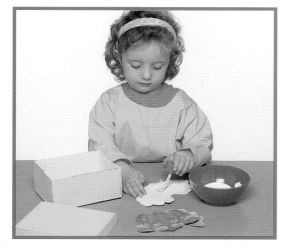

7 When the box is completely dry, glue your patterns to the box.

Vegetable-print T-shirts

Sasha is using different colours and all sorts of vegetables on a white T-shirt. If you don't want to make an all-over design, you could print just in the centre of the shirt. For a more intricate design, use smaller vegetables such as tiny onions cut in half, or a baby carrot. Use different sizes of mushroom too.

Design rules

If you are not sure about a design, print it on paper first to get a good idea of how it will look when it is on the T-shirt. Once it is on the T-shirt it will be difficult to remove or change.

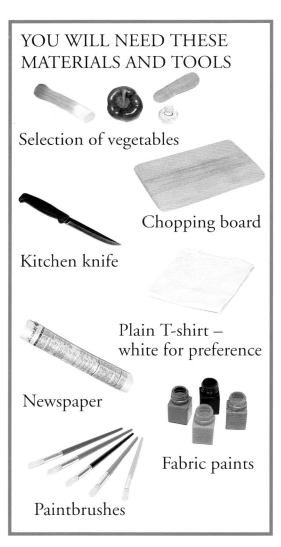

YOU WILL NEED THESE MATERIALS AND TOOLS

Selection of vegetables

Chopping board

Kitchen knife

Plain T-shirt – white for preference

Newspaper

Fabric paints

Paintbrushes

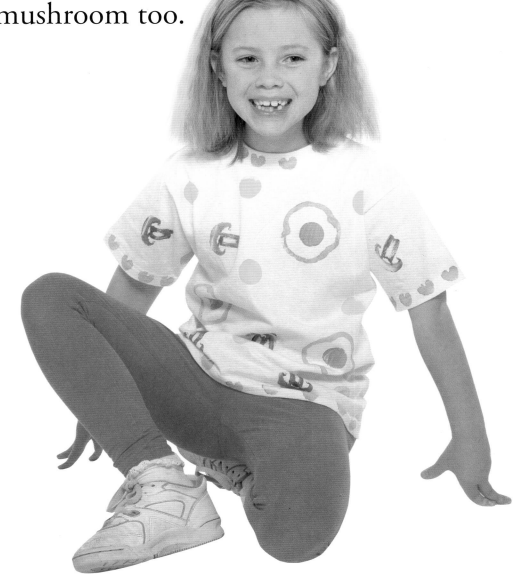

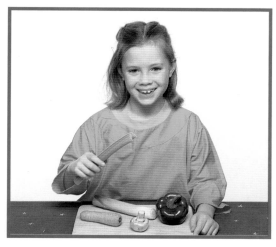

1 Choose vegetables that will make interesting prints of different sizes, such as a stick of celery (semi-circle), carrot (circle), pepper (crinkly circle), mushroom and leek.

2 Ask a grown-up to cut up the vegetables for you. Make sure that they cut round the pepper – you don't want a strip – and leave the stalk on the mushroom slice.

3 Lay the T-shirt flat and front side up on your work surface. Put some newspapers inside so that your design does not go through to the back of the T-shirt.

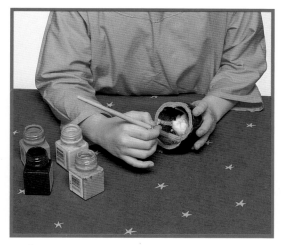

4 Paint the edge of the pepper with fabric paint. Make sure that the edge is covered with paint but don't get it too wet or it might smudge.

5 Print the pepper on to the T-shirt. Try to hold it still while it is in contact with the shirt so that the edges don't blur. You may need to repaint it between prints.

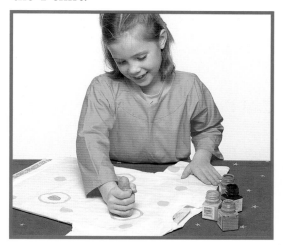

6 Paint the end of the carrot with fabric paint and use it to print in the centre of and all around the pepper prints. Try not to print over another print as the colours may run.

7 Use all the other vegetables in the same way, choosing different colours and building up an interesting design. Leave the T-shirt to dry.

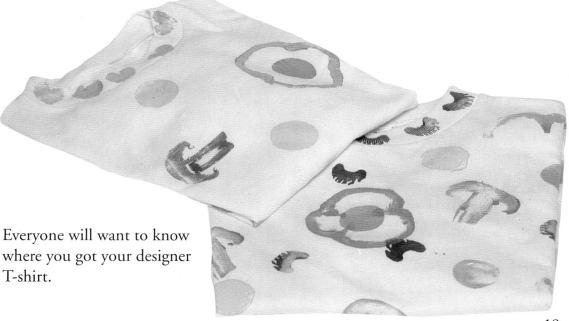

Everyone will want to know where you got your designer T-shirt.

Spotty Dog-bone Picture Frame

Frame a picture of your pet with one of these fun frames. Nicholas is using a colourful photograph of his dog. Or you could frame your paintings and put on an exhibition of your works of art.

Framing

If you are making a frame for one of your favourite pictures then you will need to make sure that the hole in the middle of your frame is cut to the right size. Measure your picture before you begin and then make the hole slightly smaller than this. If the hole is too big the backing sheet will show through.

YOU WILL NEED THESE MATERIALS AND TOOLS

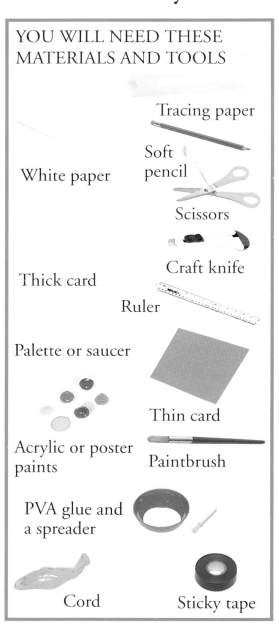

Tracing paper

White paper

Soft pencil

Scissors

Craft knife

Thick card

Ruler

Palette or saucer

Thin card

Acrylic or poster paints

Paintbrush

PVA glue and a spreader

Cord

Sticky tape

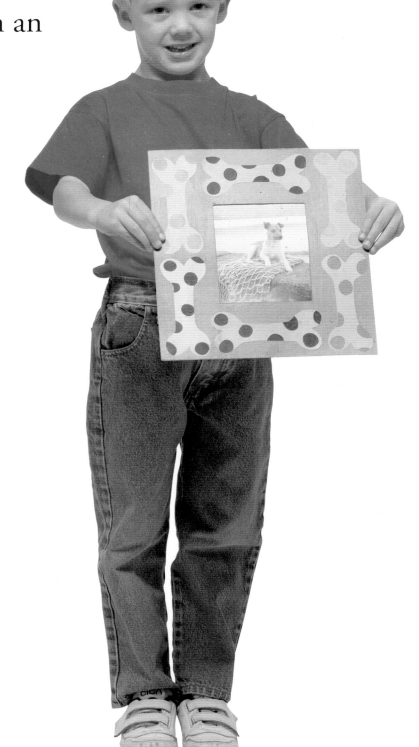

1 Using a soft pencil, trace the dog-bone template on page 6 on to white paper six times, as shown on page 5.

2 Cut out the dog bone shapes using the scissors. Take care as you cut round the curves so that you get six even-looking bones.

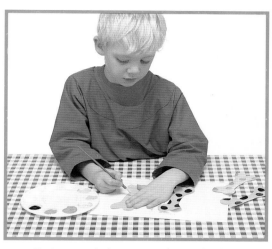

3 Paint each bone. When the background colour has dried, paint on some spots.

4 Ask a grown-up to cut the thick card for the frame, and to cut out the centre. Cut a piece of thin card slightly larger than the hole in the centre.

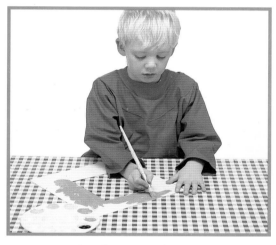

5 Paint the frame a plain colour that will look attractive with your bones and with the photograph you intend to display in the frame. Leave it to dry.

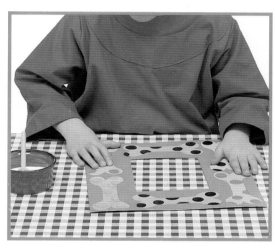

6 Glue the bones on to the frame. Push out any air bubbles with your fingers. If you have used too much glue, let it dry then peel it off.

7 Stick a loop of cord to the top of the back of the frame. Then attach the backing card with tape, leaving the top free so that you can slip your photograph inside.

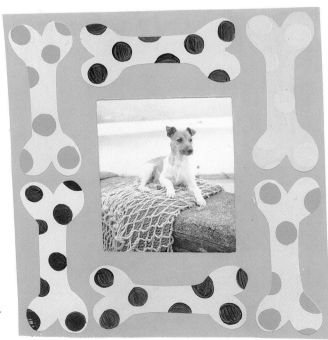

A special frame for a special photograph.

Marbled Pencils and Pencil Pot

The exciting thing about marbled papers is that each sheet is different and unique. Marbling is simple to do, but always ask a grown-up to mix the oil paint as you must not get turpentine near your eyes or mouth. You can buy ready-mixed marbling colours from craft or hobby shops.

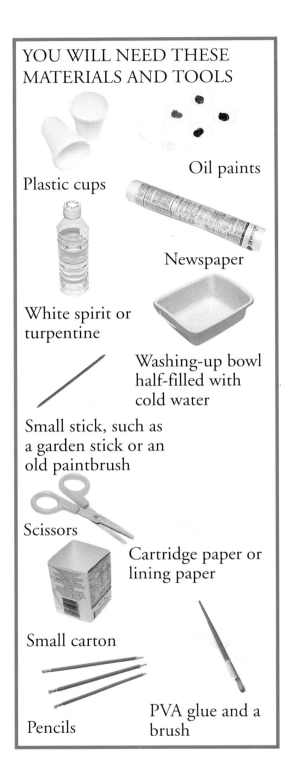

YOU WILL NEED THESE MATERIALS AND TOOLS

Plastic cups

Oil paints

White spirit or turpentine

Newspaper

Washing-up bowl half-filled with cold water

Small stick, such as a garden stick or an old paintbrush

Scissors

Cartridge paper or lining paper

Small carton

Pencils

PVA glue and a brush

Marbling technique

The secret of good marbling is not to pour too much paint into the water at once. You can always add more after you have made one sheet of paper if you think it is too pale.

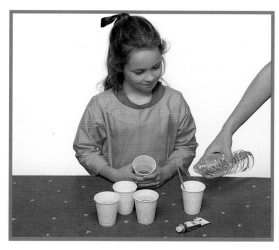

1 Squeeze a blob of about five different paints into separate plastic cups and ask a grown-up to add a small amount of turpentine. Mix well.

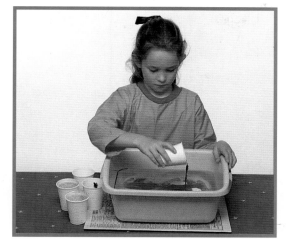

2 Cover your work surface with newspaper. Place the washing-up bowl on the work surface. Gradually pour the oil paints into the water.

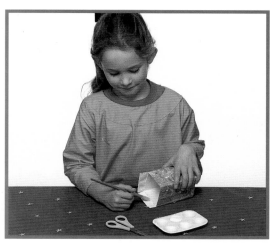

3 Mix the paints around to make interesting patterns. Make sure that you haven't got a big blob of one colour completely unmixed.

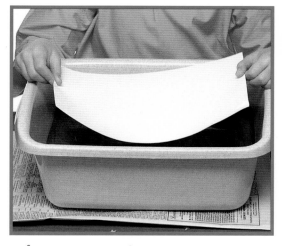

4 Cut a piece of paper about the same size as the washing-up bowl and gently place it on the surface of the patterned water.

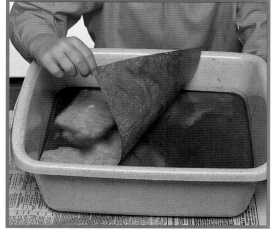

5 Remove the paper carefully and place it face up on a flat surface covered with newspaper. Try making different papers, experimenting with different colours and patterns.

6 When your papers are completely dry, use one to cover the carton. Cut it to shape, then glue it down.
Leave some paper at the top to glue down inside the box.

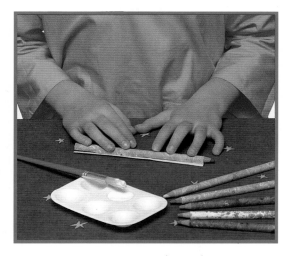

7 Cover some pencils with your marbled paper so they match your pencil holder.

Cheer up homework time with your unique pencils and pot.

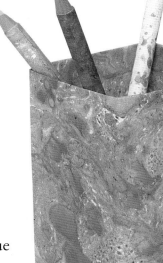

Bubble-printed Notebook

Food colouring

If you can't find coloured inks you could use food colourings instead. You may find there are not as many different colours and most of them will be paler than some inks but you will still get good results.

It is a good idea to do bubble printing as close to the kitchen sink as you can since you need lots of water and washing-up liquid to make fluffy bubbles. Don't lift a full bowl of water yourself – ask a grown-up to do it.

The secret of bubble printing is not to pour in too many colours at once. Remember you can always add more if you don't like the first sheet.

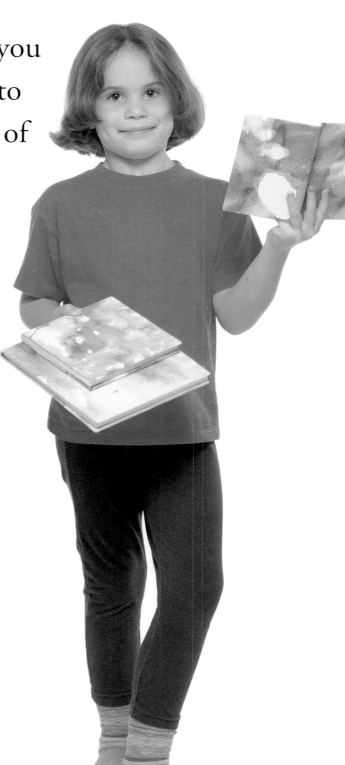

YOU WILL NEED THESE MATERIALS AND TOOLS

Washing-up bowl

Washing-up liquid

Coloured inks

White cartridge paper

Scissors

Newspaper

Notebook

PVA glue and a spreader

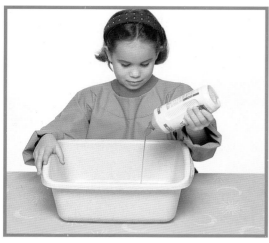

1 Squeeze a generous amount of washing-up liquid into the washing-up bowl.

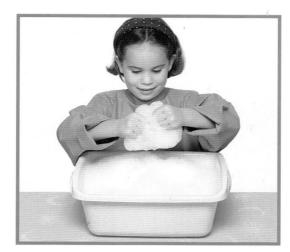

2 Add cold water and swish it around so that there are plenty of bubbles in the bowl.

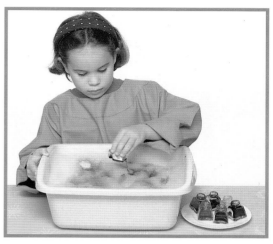

3 Gradually dribble different coloured inks on to the surface of the bubbles.

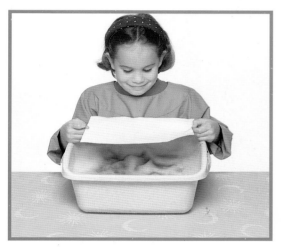

4 Cut a piece of cartridge paper about the same size as the bowl. Gently lay the paper on the surface of the coloured bubbles.

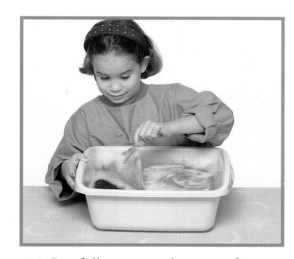

5 Carefully remove the paper from the bowl and place it face up on sheets of newspaper to dry.

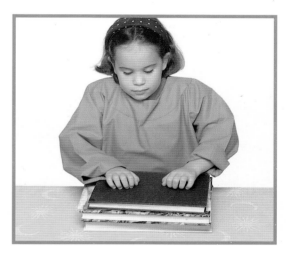

6 If the paper dries crinkly, flatten it by placing it in between some heavy books and leaving it overnight.

Decorate your notebooks, diary and address book with your individual bubble-printed papers.

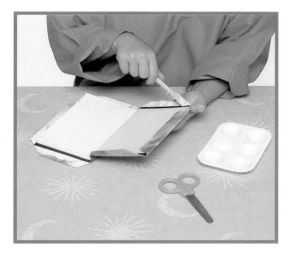

7 Open the notebook and cut the paper, adding an extra 2.5 cm (1 in) all around. Cut across the corners and cut a V at the top and bottom of the spine. Glue the extra inside the cover.

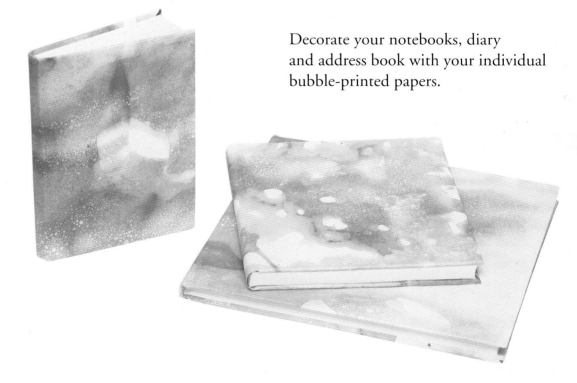

Wet-painted Table Mat and Coaster

These fun place mats are great for a party. Make one for each guest. Before you start, find a photograph of a rainbow. This will give you an idea of how different colours work together. The most exciting part of making these mats is watching the coloured inks run into each other, making new colours. Aaron has made a coaster to match his mat.

Drying tip
Place your wet papers on to piles of newspaper to dry. It is a good idea to have your newspapers piled up and ready before you start.

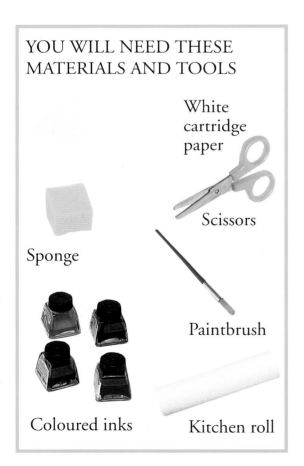

YOU WILL NEED THESE MATERIALS AND TOOLS

White cartridge paper

Scissors

Sponge

Paintbrush

Coloured inks

Kitchen roll

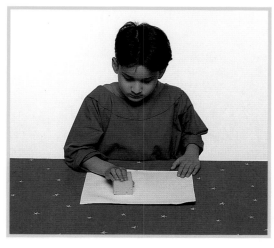

1 Cut the paper to about 20 x 30 cm (8 x 12 in). Wet the sponge, then squeeze it out and moisten the paper.

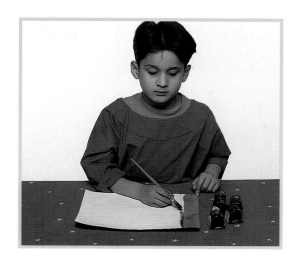

2 Load the paintbrush with ink, one colour at a time, and paint stripes down the paper.

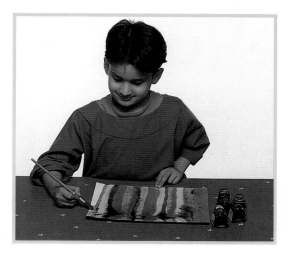

3 Continue to paint stripes until you have covered the paper and the inks are all beginning to run together.

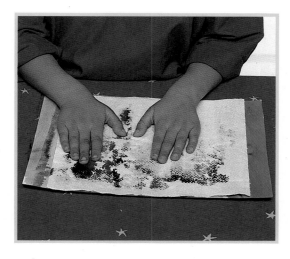

4 If there are any puddles of colour, take a piece of kitchen roll and blot them up. This will also add interest to the finished pattern.

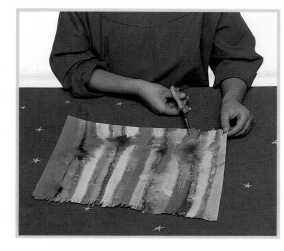

5 When the paper is completely dry, make a series of small cuts along the two long edges to create a fringed effect to the mat.

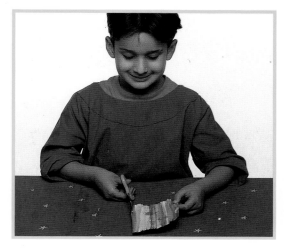

6 Make a mat for a cup or glass in exactly the same way. A piece of cartridge paper 10 x 10 cm (4 x 4 in) is ideal for this.

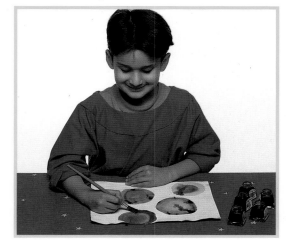

7 For other mats, change the pattern by painting circles and squares, leaving some areas of the paper unpainted if you like.

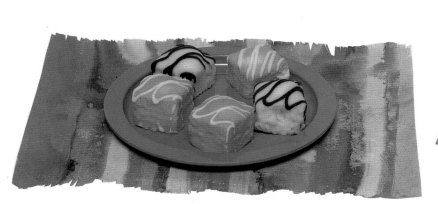

The ideal place settings for a party, or just to liven up every day.

Block-printed Stationery

You can make your own designer stationery using these block prints. Print different coloured cards and envelopes and mix and match them when you send letters to friends. Experiment with different shapes and textures, such as bits of sponge and pasta shells.

Venetia's corrugated cardboard prints are very colourful. Repaint the print blocks between each print and, if you want to change colour, wipe the block clean with a cloth.

Gift cards

If you are using this stationery yourself, simply glue the envelope down with the letter inside. If you are making a set for a gift, add a small piece of double-sided tape to the flap of the envelope. Then the envelopes can be stuck down securely simply by peeling off the backing of the tape.

YOU WILL NEED THESE MATERIALS AND TOOLS

Scissors Corrugated cardboard

Coloured paper Heavy card

PVA glue and a spreader

Acrylic or poster paints

Palette or saucer

Paintbrush Tracing paper

String Soft pencil

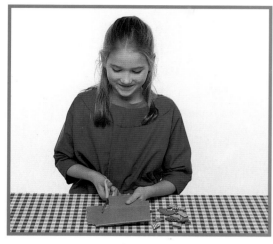

1 Cut a piece of heavy card 12 x 16 cm (5 x 6¹/₂ in). Cut out small triangles from the spare heavy card and rectangles from the corrugated cardboard. Glue these around the edges of the card.

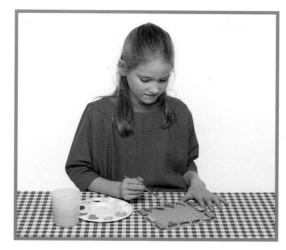

2 When the glue is completely dry, paint the shapes on the card. Use lots of different colours. Be careful not to get the shapes too wet, otherwise they might smudge.

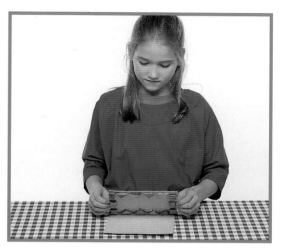

3 Cut out pieces of coloured paper the same size as the piece of card. Line up the edges and corners of the card and paper and press down hard. Repeat for each sheet of paper.

4 While the papers are drying, make some envelopes. Using a soft pencil, trace the envelope template on page 6, then retrace it on to a piece of coloured paper. Cut it out.

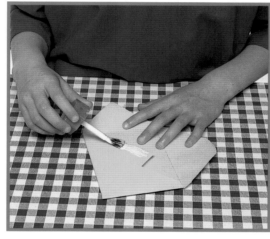

5 Follow the instructions on the envelope template to fold it and glue it together. Make one envelope for each sheet of paper.

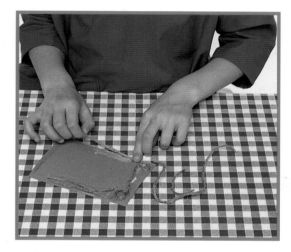

6 Cut out a piece of card the same size as the envelopes. Glue the string around the edge and paint it to make an interesting pattern.

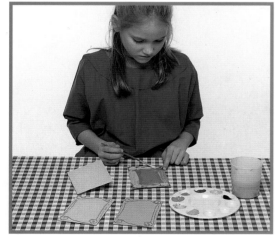

7 Print the envelopes in the same way as you printed the paper.

Family and friends will soon know who is writing to them.

Finger-painted Flowers

These wild and colourful flowers brighten up any room and don't even need to be watered. The great thing about making your own flowers is that you can choose which colours you want them to be and if you paint the backs and fronts differently, you can turn them round when you get bored.

Flower arranging

To make a beautiful flower arrangement put a piece of florist's foam or crumpled newspaper in the bottom of the vase. This will help to keep the flowers upright.

YOU WILL NEED THESE MATERIALS AND TOOLS

Tracing paper

Soft pencil

Thick coloured papers

Scissors

Palette or saucer

Acrylic or poster paints

PVA glue and a brush

Thin paintbrush

Garden sticks

Sticky tape

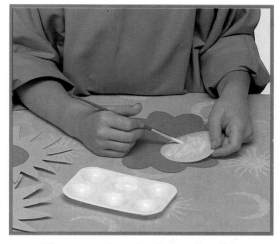

1 Using a soft pencil, trace the flower, circle and leaf templates on page 7 on to coloured paper, as shown on page 5.

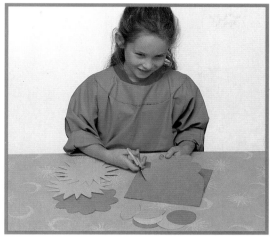

2 Using the scissors, cut out the shapes. You will need two matching flower shapes, two circles and two leaf shapes for each flower.

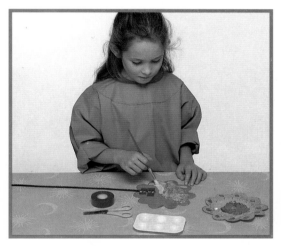

3 Glue a circle of coloured paper on to the centre of each flower. Make sure the flowers and circles are different colours.

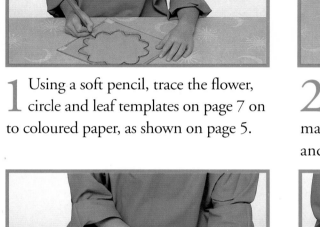

4 Dip your fingers one at a time into the paint and then press them on to your flowers. Use a different finger for each colour. Cover the flowers with finger prints.

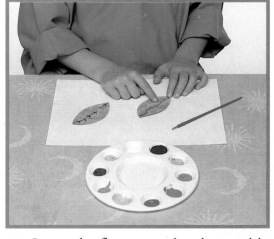

5 Leave the flowers to dry thoroughly while you make the leaves. Finger paint the leaf shapes with different green paints and paint a fine line of colour down the centre of each one to make the vein. Leave them to dry.

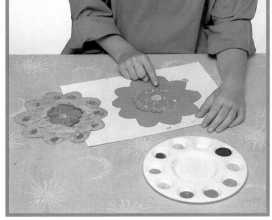

6 Use a piece of sticky tape to attach a garden stick to the back of a flower. Glue a matching flower on to the back and gently press it down to make sure that it sticks.

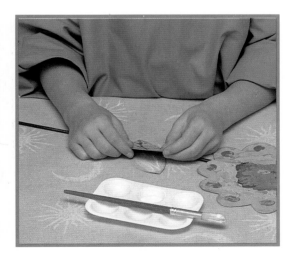

7 Attach the back of one leaf to the garden stick with sticky tape and glue a matching leaf to the back of it.

Everlasting flowers brighten up the dullest day

31

Wooden-spoon Puppets

Tania and Joshua are having fun painting their puppets. Create your own theatre characters on wooden spoons then put on a show to impress the grown-ups. Hide behind the sofa and use its back as the stage. Try to give all the characters different voices too.

Drying tip

Stand the spoons in a jam jar while the wet heads dry. To dry the handles, stand the heads in a big lump of modelling clay.

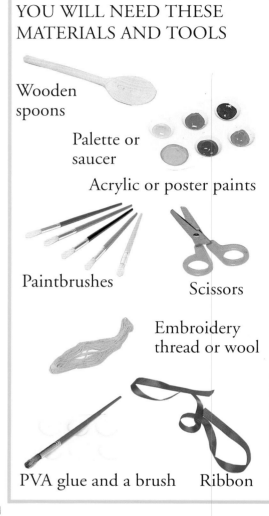

YOU WILL NEED THESE MATERIALS AND TOOLS

Wooden spoons

Palette or saucer

Acrylic or poster paints

Paintbrushes

Scissors

Embroidery thread or wool

PVA glue and a brush Ribbon

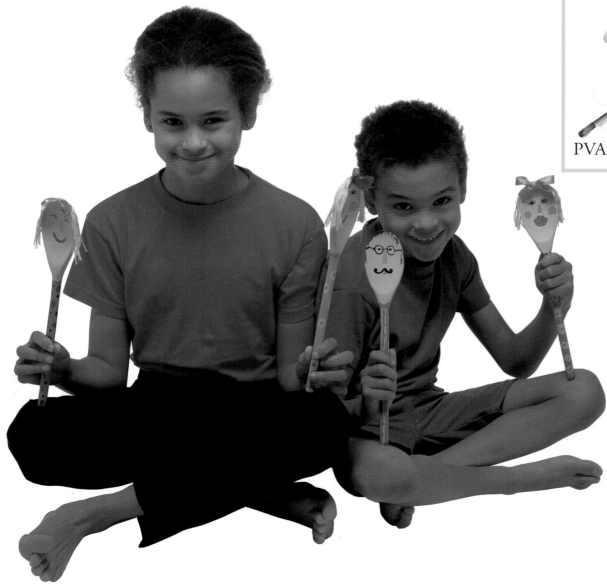

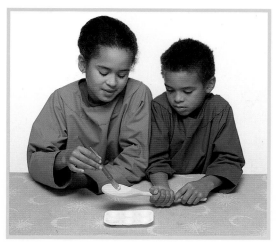

1 Paint the head of the spoon and leave it to dry.

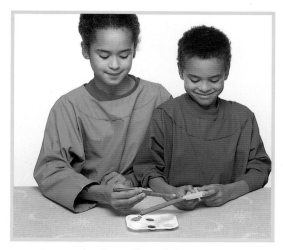

2 Paint the handle of the spoon using a different colour and leave it to dry.

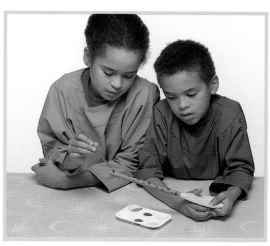

3 Decorate the handle with spots, stripes, collar, buttons or a bow tie.

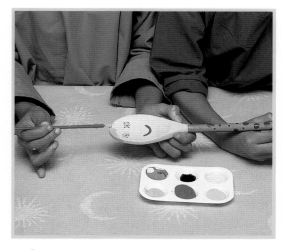

4 Paint a face on to the head of the spoon and leave to dry. If you are making a man puppet, paint on some hair or, if you prefer, leave him bald.

5 If you are making a lady, cut about 15 strands of embroidery thread all the same length. Tie a shorter piece around the middle of them to keep them together.

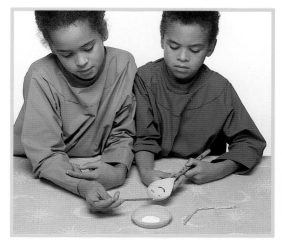

6 Glue the hair on to the top of the lady's head and leave it to dry. Try not to use too much glue. If you do, let it dry, then peel off the excess with your fingers.

Make your own theatre and impress your friends with your own plays.

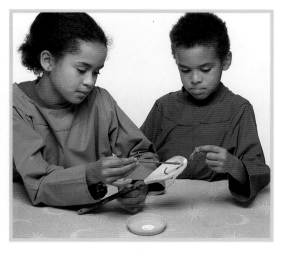

7 Tie the ribbon into a bow and glue it on to the hair.

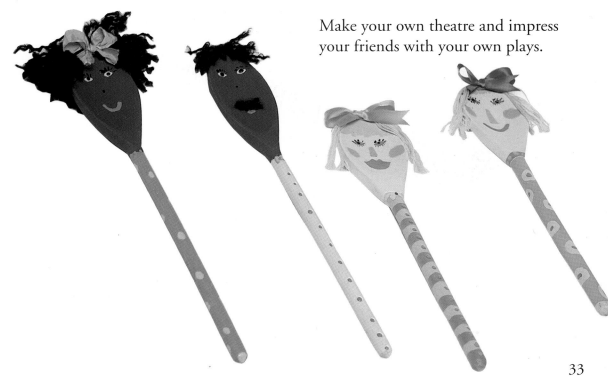

Wax-resist Badges

Add a personal touch to a favourite outfit with a badge made with the magical technique of wax resist. Alice is using wax crayons, which give a colourful result, but the technique also works in black and white if you use a candle to draw your design. Remember that as your badge is made out of card, you can't wear it outside in the rain.

Age badges

A variation on this idea is to make an age badge for you or a friend, or your little brother or sister. Vary the colours to suit the personality of the wearer.

YOU WILL NEED THESE MATERIALS AND TOOLS

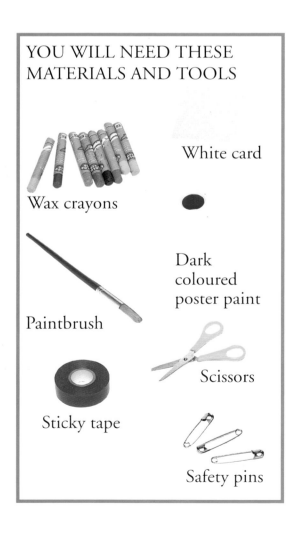

Wax crayons

White card

Paintbrush

Dark coloured poster paint

Sticky tape

Scissors

Safety pins

1 Collect together all the materials you will need for the project before you begin.

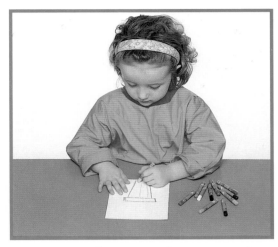

2 Draw a flowerpot shape on to the card with wax crayons. The brighter the colours, the more attractive the finished badge will be.

3 Add a cactus in a different colour, then decorate the pot and cactus using as many colours as you like.

4 Paint over your wax drawing with poster paint. Don't worry about the edges too much as you are going to cut out the picture later.

5 When the paint is completely dry, you should still be able to see your wax drawing. Cut around the edge of the cactus and flowerpot.

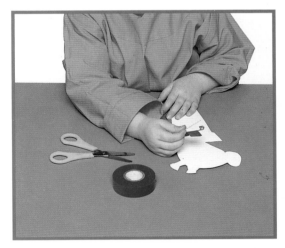

6 Turn the badge over. Cut a small piece of sticky tape and use it to attach the safety pin to the middle of the badge.

It's obvious who is on your team with these colourful badges.

Flowery Glass

These jolly flowers will liven up any glass frame. You could also use lots of smaller flower stickers to decorate a jam jar to use as a pencil pot or flower vase.

Aaron is decorating a frame but you can stick the flowers on the inside of a real window as in step 7.

Handy hints

Plastic film is quite difficult to smooth down without getting air bubbles trapped. The trick is to work slowly, peeling off a bit of backing and smoothing as you go.

YOU WILL NEED THESE MATERIALS AND TOOLS

Plastic film

Scissors

Sticky tape

Palette or saucer

Acrylic paints

Paintbrushes

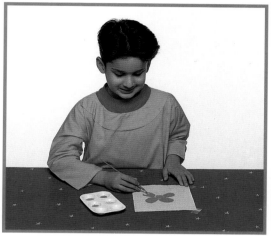

1 Cut two pieces of plastic film the same size. Stick the corners of one piece to your work surface with sticky tape. Do not remove the backing.

2 Paint the centre of a flower on to the centre of one piece of the film. Use a bright colour such as red, purple or yellow.

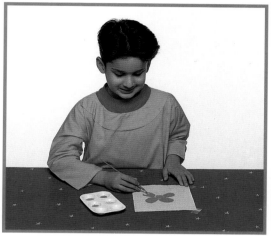

3 Using a different colour, paint five petals around the centre of the flower. Take care not to smudge the centre as you paint.

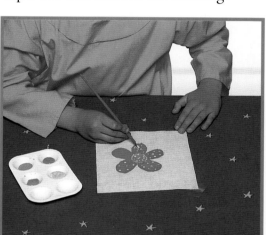

4 Decorate the flower with spots of a different, bright colour. Leave the flower to dry completely.

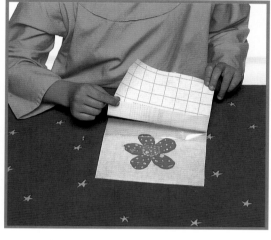

5 Take the second piece of film and carefully peel away the film's backing. Stick it over the flower. Work slowly, smoothing out any air bubbles with your fingers as you go.

6 If you get an air bubble, prick it with the point of a needle and smooth it out, then carefully cut around the flower.

7 Peel off the backing and stick the flower to the inside of your window.

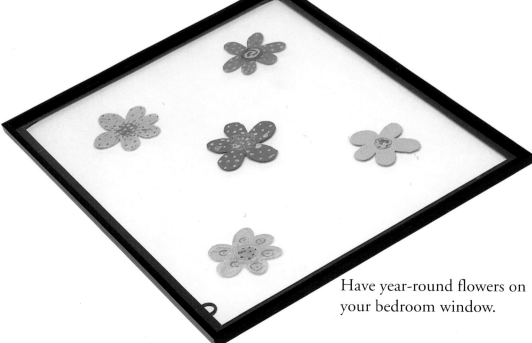

Have year-round flowers on your bedroom window.

Flick-painted Starscape

This is a messy project so be sure to cover your work surface with lots of newspaper or scrap paper, or, if the weather is fine, do your flick painting outside. You can use any size of box for the planet story.

The planet and rocket will move if you blow them or put the box by an open window.

If you want to make the inside of the box sparkle, add some glitter or cut out star shapes from kitchen foil and scatter them around the box.

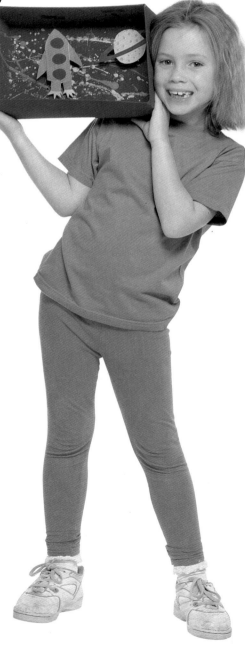

Large-scale scene

A shoebox was used for this project but if you want to make a really big scene, get a box from the supermarket that had apples or oranges in it. Remember to make more than one of each mobile if you are using a big box.

YOU WILL NEED THESE MATERIALS AND TOOLS

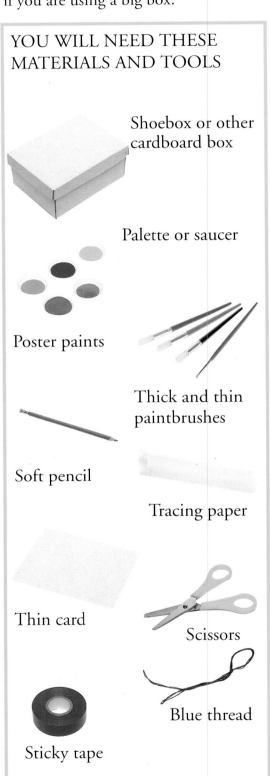

Shoebox or other cardboard box

Palette or saucer

Poster paints

Thick and thin paintbrushes

Soft pencil

Tracing paper

Thin card

Scissors

Blue thread

Sticky tape

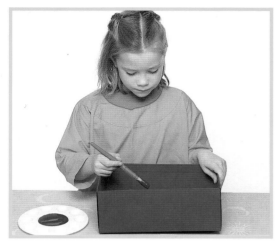

1 Paint the shoebox inside and out using blue paint. You don't need the lid so don't bother with that. Leave the box to dry, then stand it on a wipe-clean surface, inside a cardboard box, or on a surface covered with newspaper.

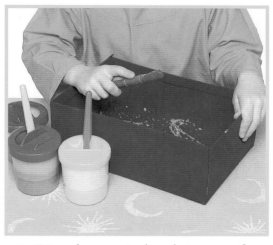

2 Dip a large paintbrush in one of your pots of poster paint and flick the paint into the box. For fine splatters, tap the brush handle on the edge of the box. Repeat this with the different coloured paints.

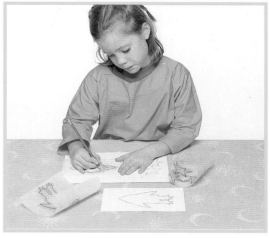

3 Leave the box to dry thoroughly while you make the mobiles and decorations. Using a soft pencil, trace the star, planet and rocket templates on page 6 on to pieces of card, as shown on page 5.

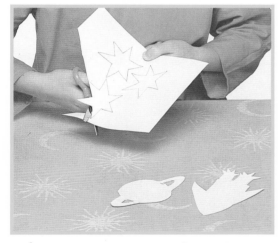

4 Cut out the shapes. If your box is large, you will need more than one of each. You will also need some stars for the outside of the box.

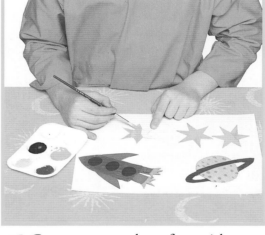

5 Cover your work surface with scrap paper, then paint each shape. Choose yellow, gold or silver for the stars and bright colours for the planet and rocket.

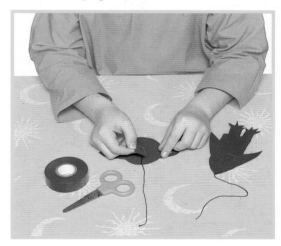

6 Use a piece of sticky tape to attach a length of blue thread to the shapes to hang inside the box. Glue some of the stars to the top and sides of the box.

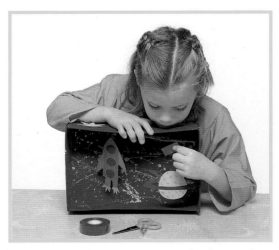

7 Use sticky tape to attach the rocket and planet to the roof of the box.

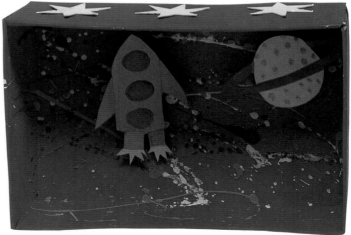

Your own space scene will amaze your friends.

Colour-combed Postcards

Receiving one of these jolly cards in the post will brighten up a special friend's day. You could also use the cards as party invitations, writing all the details – date, time and so on – on the back. Whatever you do with the cards, make sure that the paint is dry first.

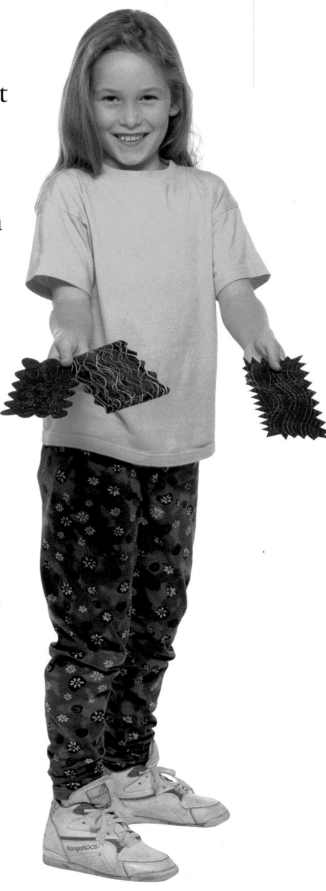

Kirsty is making interesting patterns with a plastic picnic fork. You could, if you prefer, use a biscuit-cutter and twist it round in the paint to make a slightly different pattern. Remember to wash it well afterwards.

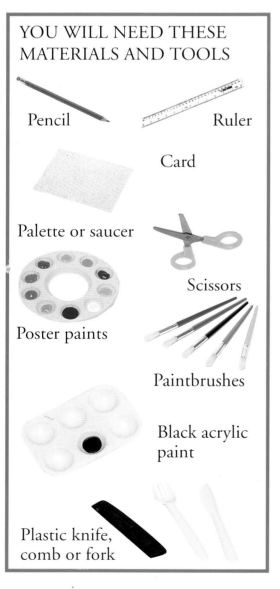

YOU WILL NEED THESE MATERIALS AND TOOLS

Pencil

Ruler

Card

Palette or saucer

Scissors

Poster paints

Paintbrushes

Black acrylic paint

Plastic knife, comb or fork

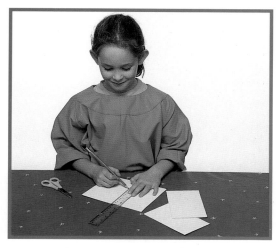

1 Use the pencil and ruler to mark out postcard-sized rectangles on your card. Carefully cut them out using the scissors.

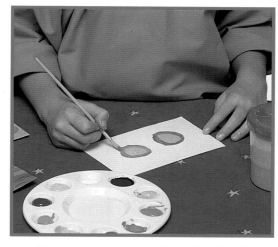

2 Paint each postcard with a bright abstract pattern, using different coloured paints. Leave them to dry thoroughly.

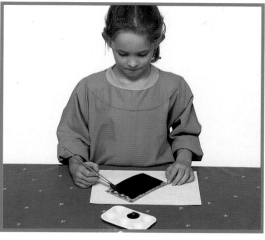

3 Put a sheet of scrap paper on your work surface. Then paint over the pattern on one of your cards with black acrylic paint, going right to the edges.

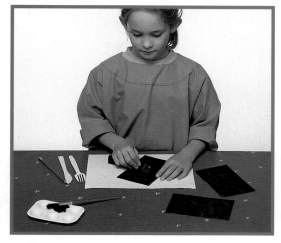

4 While the paint is still wet, take the comb or fork and make patterns in the black paint to reveal the colours underneath. Leave the card to dry thoroughly while you paint and comb another one.

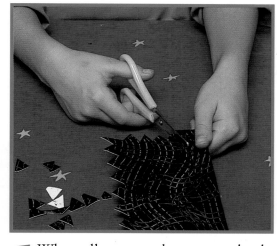

5 When all your cards are completely dry, decorate their borders. Use the scissors to cut small triangles from the edges of one card to give a spiky effect. Alternatively, make a wavy edge.

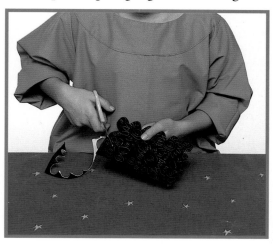

6 Cut scallops from the edge of one card. You could post these cards as they are or put them in envelopes.

Colour-combed frame

If you are specially pleased with one of your designs, you could frame it to hang on your bedroom wall (see Spotty Dog-bone Picture Frame, page 20).

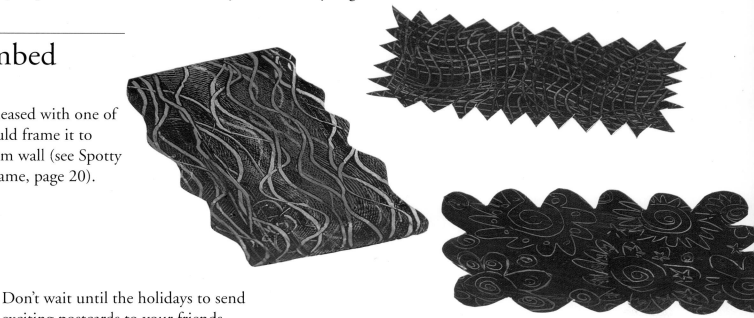

Don't wait until the holidays to send exciting postcards to your friends.